KEEP YOUR COMPUTER RUNNING RIGHT!

FOR FEWER:

- ☑ CRASHES
- ☑ GLITCHES &
- ☑ ANNOYING ERRORS

By Elliott Stern

Shake It! Books, LLC, P.O. Box 6565, Thousand Oaks, CA 91359
Toll Free: (877) Shake It
www.**shake**that**brain**.com

This book is available at special discounts for bulk purchase for sales promotions, premiums, fund-raising and educational use. Special books, or book excerpts, can also be created to fit specific needs.

Library of Congress Card Number: 00-105935
ISBN: 0-9667156-4-0
10 9 8 7 6 5 4 3 2 1
First Edition

Contents

More Contents

Part II: Preventive Maintenance Tips
Keeping Your Computer Running Right

Introduction

Why is this computer book *smaller* than any other computer book?

Because I've worked as hard as possible... to make it as simple as possible. So you really can improve the performance of your computer—and get a lot fewer headaches—regardless of your level of skill. In fact:

If you know how to type a letter and save it, you're "advanced" enough to follow this book.

Here's a fun, easy program for all of us who've gotten frustrated with our computers—for all of us who've smacked our monitors, pounded our fists on the keyboard or screamed out loud, "I'm mad as hell and I'm not taking it anymore!"

Starting today, you *don't* have to take it anymore. Relief is just pages away.

You'll learn how to get your computer running better than ever. Plus, your **Tune Up Calendar** (pages 126-127) will show you what to do daily, weekly and monthly. So you can *keep* your computer running right. And all it takes is 15 minutes a week or less. (Usually, less.)

So take a deep breath, clear your head and prepare to get your computer to work smoothly, simply and nearly error free.

Elliott Stern ("The Maestro")
Los Angeles, CA 2000

P.S.

Having spent 15 years working with corporate and individual clients, I know what works, what doesn't, and what does work but is too darn complicated for most non-techies to follow. That material, if you're super-adventurous, you'll find on my website, **www.pcmaestro.com**.

Part I
Performance Tips
Getting Your Computer Running Right

How Well is Your Computer Running?

You're about to learn some terrific tips to keep your computer in peak condition. But first, let's take a look at some vital signs—indicators of your computer's current state of health.

At the end of this section we'll compare your original findings with your "new and improved" test results. These before and after comparisons will serve as proof as to just how far you and your computer have come.

Step 1:

Check your computer's "performance status"—the higher the level, the faster and more efficient your computer works

Click on **Start**

Go to **Settings**

Click on **Control Panel** Windows *Me*? See page 125

Double click on **System**

Click on **Performance Tab**

The percentage indicated for System Resources is your current performance level.
Write your current performance level here:

_____ % free

To return to your desktop (the thing with all those neat icons) close the System Properties window. Then close the Control Panel window. (Phew! You're back on familiar ground.)

Your time at the keyboard to complete this task: 0 minutes, 45 seconds

Step 2: Check your available hard disk space—if your computer seems sluggish, you may be running out of room

Double click on **My Computer** (an icon on your desktop)

Right click on **C:** (your first, and maybe only, hard drive)

Left click on **Properties**

Next, look at the numbers that identify used and free space. Write the number for **free space** here:

Free space (Drive C:) _____ bytes

In addition to a C: drive, you may have other **hard drives** as well (D:, E:, etc.).
If so, do this test for those drives as well.

Free space (Drive D:) _____ bytes

Free space (Drive E:) _____ bytes

Your time at the keyboard to complete this task: 0 minutes, 51 seconds

Now let's move on to Performance Tips. These easy-to-follow tune-up tips will increase your computer's **performance level** and the **amount of available space** on your hard drive—resulting in faster, more reliable performance.

You'll feel a sense of accomplishment and a new lease on life. Even better ...

"Your computer will give you a lot fewer headaches!"

Performance Tip #1

Give Your Computer a Nap (and a Zap of New Energy)

Lots of people hit a slump around mid-afternoon. (The afternoon blahs.) Time for a cup of coffee or—if you can manage—a midday nap. If your computer starts performing sluggishly, is acting "cranky" or just won't behave, chances are it's time to shut it down and give it a nap.

Your time at the keyboard to complete this task: 1 minute, 15 seconds

Windows needs a nap because your computer leaks memory—like this:

Computer memory at 9 AM.

Computer memory at 10 AM.

Computer memory at 11 AM.

Computer memory at 12 Noon.

Computer memory at 1 PM.

Computer memory at 2 PM.

Computer memory at 3 PM.

Computer memory at 4 PM.

Computer memory at 5 PM

The quick nap will zap your computer back to life—restoring memory that may have leaked over time. In fact...

Giving your computer a nap can be the quickest and most productive tune-up you'll ever use.

To nap (or restart) your computer:

Step 1: Exit all programs

Step 2: Click on Start

Step 3: Click on Shut Down, then Restart

Does your computer seem a little peppier... a little more willing to follow your every command? *You bet it does!*

Go Ahead, Check it Out

Check your computer's **post-nap** performance level (see page 10 for instructions) and write it down here:

_____ % free

Now compare the number above to your old performance level number (what you wrote on page 10). You should see a significant difference. For example, the performance level on my own computer just went from 81%... to 92%. After about four hours of work, all it needed was a little nap. (If you don't see a big difference on your own computer, chances are you booted up just before you tried this tip.)

Keep in Mind

You'll rarely—if ever—find your computer operating at a 100% performance level. Depending on your system, software add-ons and configuration, your normal starting level will probably be around 80 to 95%. Check this number throughout the day. You'll be amazed at how much leakage you have. But here's the good news: Now you know how to give your system a nap—and a zap of energy!—whenever you'd like.

Performance Tip #2

Take Out the Trash

It's not enough to just fill up your trash cans. Once a week you need to take that trash out to the curb so the garbage truck can haul it away. Same goes for your so-called "deleted" files—files that were merely sent to the Recycle Bin (the trash can). Now it's time to get rid of your trash. You'll free up space on your hard drive and further improve your computer's performance.

**Your hard drive is valuable real estate.
You can put it to maximum use...
or turn it into a dumping ground
for every scrap and file you ever created.**

Your time at the keyboard to complete this task: 0 minutes, 23 seconds

To take out your trash—and save your computer's environment:

Step 1:
Double click on Recycle Bin (one of those icons on your desktop)
You should see all the files you previously deleted.

Step 2:
Click on File

Step 3:
Click on Empty Recycle Bin

"In California, they don't throw their garbage away —they make it into TV shows."
Woody Allen

"Hey, who stole my trash?"

If your Recycle Bin is empty, or contains just a few files, it may mean you're someone who never, or rarely, deletes a file. If you're guilty as charged, ask yourself:

"Do I really need that 1986 Resumé file?"

Then read *Performance Tip #7,* page 43.

Performance Tip #3

Clean Out Your E-Mail Boxes

Chances are you send and receive lots of e-mail—either for work, fun or the fun of not working. But when all these messages stay stored on your computer, the files that hold them can quickly become bloated. This may even prevent you from **receiving** new e-mail.

That's bad.

Conversely, **deleting** old e-mail messages will shrink your files—helping to ensure you receive all your e-mail and making your system a lot more efficient.

That's good.

Your time at the keyboard to complete this task: 5 minutes, 12 seconds

Pop Quiz

Q: When you delete your e-mail, does it really get deleted?

A: For most e-mail programs, it merely gets filed in your **e-mail trash folder** (or waste basket) until you empty it! You'll learn how to empty your e-mail trash on the very next page.

But if you use **AOL**—or an on-line e-mail service like **Hotmail**, **Juno**, or **Yahoo! Mail**—your e-mail files may not be stored on your computer at all. Most likely, they're stored on an **e-mail server** provided by the service. (That's good.) But these services may limit the amount of space or number of messages you can have on their system. (That's not so good.) So be sure to clean out your old e-mail files before your service **deletes** old e-mails or **prevents** you from receiving new ones.

Caveat Empteor (Let the Emptier Be Warned)

To clean out your e-mail:

Step 1: Delete e-mails you've received

Step 2: Delete e-mails you've sent

Step 3: Empty that trash! To Find out how, follow the instructions for your e-mail program on the list
below. (For earlier versions, go to www.pcmaestro.com.)

MS Outlook, Outlook Express, Internet Mail (Versions 5x)

Click on **Tools**

Options

Maintenance tab

Check the box **next to "Empty Messages from 'Deleted Items' folder on exit"**

Now every time you exit your mail program, your Deleted Items folder will be cleared.

Eudora, Eudora Light (Versions 4x)

Click on Special

Tools

Empty Trash

Netscape Communicator (Versions 4x)

Go to Your E-mail Program

Click on File

Empty Trash on Local Mail

Keep in Mind

If you've created various mail folders to manage your mail more effectively, remember to review each of these folders for old, outdated messages and delete them as well.

Performance Tip #4

Keep Your Temporary Internet Files **Temporary**

Want to improve your Internet performance without springing for a faster computer or a high-speed connection? Just clear out your **Temporary Internet Files** (also known as **Disk Cache**) on a regular basis and see how smooth and hassle-free surfing can be.

Don't worry, it's easy.

Your time at the keyboard to complete this task: 1 minute, 23 seconds

The Problem:

While surfing the Internet, your computer is constantly juggling temporary files. It's these files that help you return to an Internet page more quickly than the network could retransmit it. (For example, when you use the Back button.) Every time you visit another website, you're asking your computer to juggle more and more files. Call them Temporary Internet Files or Disk Cache, this accumulation of files clutters your system over time and can slow your browser down to a crawl. Or worse.

Just like a juggler who only has two hands, your Internet browser can only juggle so much before something drops and ... CRASH!

The Solution:

After every Internet session, clear your Temporary Internet Files.

"Won't clearing these files delete my bookmarks, favorite places, or stock portfolio?"

Not to worry. Those and other "personal preference items" are not related to Temporary Internet Files or Disk Cache and are stored somewhere else. Relax. Life is good. Clearing these files will **not delete** your personal preference items.

To Clear Your Temporary Internet Files:

Find your browser on the list below. (For earlier versions, go to www.pcmaestro.com.) Then clear those files and try surfing the Net again. You and your computer should feel a nice improvement!

MS Internet Explorer (Versions 5x)

Click on Tools

 Internet Options

 General tab

Go to Temporary Internet Files

Click on Delete Files

 OK (Do not check "Delete all offline content.")

Netscape Navigator and Communicator (Versions 4x)

Click on Edit

 Preferences

Double click on Advanced (Don't worry, it's not.)

Click on Cache

 Clear Disk Cache (on right side of window)

AOL (Versions 5x)

Click on **My AOL**
>**Preferences**
>**WWW** (World Wide Web)
>**Internet Options** (If it's there, click on it. If not, go to:)
>**Temporary Internet Files**
>**Delete Internet Files or Delete Files**
>**OK** (Do not check "Delete all offline content.")

By the way, you do **not** need to be connected to the Internet to clear your Temporary Internet Files. Also, try clearing those files **during** a session—especially if you're visiting lots of different sites. You may find yourself landing on your next site a bit faster than before.

Keep in Mind

If your system has more than one browser program on it, clear Temporary Internet Files in **each browser program**—even if you never use that browser!

For example: If your computer came loaded with Windows, it probably also came loaded with Internet Explorer. Even if you use a different Internet browser—say Netscape—Internet Explorer may still be on your system, accumulating its own set of Temporary Internet Files and cluttering up your system with no benefit whatsoever. So be sure to get rid of those unnecessary files. All they're doing is slowing you down.

Remember, you can find instructions for earlier browser versions at www.pcmaestro.com.

Performance Tip #5
Do the Defrag

Your computer's hard drive is like a big jigsaw puzzle.

REALLY BIG
With millions of pieces

Over time, however, those pieces break apart, or become **fragmented**. There are parts of programs here, pieces of data there. Little by little, your computer has to work harder and harder to collect and arrange those pieces. **It also works slower**.

The solution? Do the defrag—**defragment** your drive to organize those pieces and bring them closer together. **Your hard drive will start your programs faster and most operations will go a lot smoother**.

> Your time at the keyboard to complete this task: 1 minute, 12 seconds

Step 1: Disable your screen saver

If you've never run your defrag utility—or can't remember the last time you did—save yourself time and frustration by disabling your screen saver before you defrag. Otherwise, your defrag program will keep starting over each time your screen saver kicks in. (If you've run defrag recently, don't worry about disabling your screen saver. Just move on to Step 2).

To disable your screen saver:

Exit all programs

Right click **anywhere on your desktop** (except on an icon or a task bar)

Left click on **Properties**

Click on **Screen Saver tab**

Click on **the arrow** (in the box under Screen Saver) and

Scroll to **None** (Or change the Wait time to 60 minutes)

Click on **Apply**, then **OK**

Step 2: Do the defrag

Exit all programs

Click on **Start**

Go to **Programs**

Accessories

System Tools

Click on **Disk Defragmenter** (When asked: "Which drive do you want to defragment?" select All Hard Drives. If you just have one hard drive, select C.)

For Windows 95

Click on OK (Windows will now examine your hard drive and tell you what percent defragmented it is.
If told: "You don't need to defragment this drive now," continue anyway.
A hard drive that's even 1% fragmented can slow things down.)

Advanced (to make sure there's NO CHECK in the box marked "Check drive for errors.")

OK

Start

For Windows 98 and Windows Me

Click on Settings (to make sure there's NO CHECK in the box marked "Check drive for errors.")

OK

OK (again!)

Step 3: Re-enable your screen saver

After you "do the defrag," be sure to re-enable your screen saver by returning your settings to their original values. Or leave the Wait time at "60 Minutes" and you're set to defrag whenever you want.

Don't Let "Drives Contents Changed" Drive You Crazy

Even if you disable your screen saver (or set the Wait time to 60 minutes) you may still see the message "Drives Contents Changed." At this point—even if your defrag is "98% Complete"—it may reset itself to "0" and start the process all over again. (This may even happen a number of times.)

If you're sitting there staring at the monitor, you can begin to feel like Sisyphus—like you'll never get to finish defragging. So be smart about it: Get up. Go to the bathroom. Grab a soda. Do **anything** other than sit there staring at that screen!

Three to five minutes later—when you come back to your desk—your computer will feel refreshed... and so will you.

This Concludes the "Beginners" Section of Performance Tips

Time to feel proud of yourself. You've done a lot to improve your computer's performance—and you didn't need to call Tech Support.

But it's also time to up the ante.

So take a deep breath… roll up your sleeves… and prepare to be gently guided to higher ground.

Why Not Schedule Maintenance Tasks to Run Automatically?

Windows 98 and *Me* include a Maintenance Wizard and Scheduled Tasks option that can schedule certain maintenance tasks—like defrag or ScanDisk—to run automatically, usually when you're sleeping. But relying on schedulers can have serious drawbacks: If your computer isn't running at the scheduled time, a scheduler may miss its assignment; a glitch in your system can also foul the works. In either case, you could assume your scheduler has done its magic when it may not have. Better to become your own wizard and be sure your computer gets all the protection it needs.

Performance Tip #6
Say Goodbye to Windows Temp Files

Time to get rid of those nasty, extraneous temporary files—also known as temp files.

Windows creates temp files to help you run two or more programs at once. Under normal circumstances, these temp files disappear and are deleted when you exit your programs. That's what should happen. Because temporary files are designed to be just that—temporary.

However

Sometimes these "temporary" files fail to get deleted. At this point, they serve no other purpose than to **clutter up your computer** and make it work **less efficiently**.

So let's get rid of them!

Your time at the keyboard to complete this task: 2 minutes, 55 seconds

Don't Worry, Be Temp Free

Deleting files is safe and easy.
Just **Restart** your computer (see page 15)
and follow two simple steps...

Step 1: Find out how many temp files you have

Exit all programs

Click on **Start**

Go to **Find or Search**

Click on **Files or Folders**

Type ***.tmp in the Named: box**

Select **C:** (or any other hard drive) **for the Look-in: box**

Check **Include subfolders** (under Advanced Options in Windows *Me*)

Click on **Find Now or Search Now**

Don't be alarmed if your screen fills up with long lists of files.
Just look at the bottom of the window and see how many temp files you have.
(You'll find out why on page 41.)

Don't Forget

Before going on to Step 2, make sure all the files that are listed are truly **temp files**. To check, go to your list of files (the "Name" column) and look at the **file extension** for each file (that is, the last 3 letters after the dot). All the files you see should end with the extension **.tmp** or **.TMP**. **Don't delete any file that doesn't end in these three letters!**

Step 2: Delete your temp files on each hard drive

If you have less than 500 temp files:

Click on **Edit**
Select All
Hit **Delete key**

If you have more than 500 temp files, it's best to delete them in small groups—like this:

Click on **the NAME of the first file in the list**
Move down **the list 400 to 500 files**
Hold down **the Shift key and click on the NAME of the last file in the group**
(All files between the first and last files you clicked on should be highlighted.)
Hit **Delete key**

Relax. It's going to take some serious time to delete a large number of files. Your computer may even seem frozen. Just try to be patient and wait until it's finished. Finally, repeat this process until all files are deleted on each hard drive.

Keep in Mind

After deleting your temp files, remember to:

1. Restart your computer
2. Empty your Recycle Bin (*Performance Tip #2*)
3. Defrag again! (*Performance Tip #5*)

Performance Tip #7

Ditch Old Files and Folders You Don't Need (And Find Some You Do)

Everyone's great at creating new files. But how are you at **deleting files?**

 Deleting files and folders is one more way to get rid of junk you don't need. Not only will it make it easier to find the files you do need, deleting files will unburden your hard drive, resulting in **better performance** for your machine.

This is like taking a load of bricks from your trunk. You won't miss 'em... and your car will thank you.

INTERMEDIATE

Your time at the keyboard to complete this task: 0 minutes, 58 seconds

Just So We're Clear

A file is any letter or document you create. A folder is where you place those files, depicted by that little yellow icon that looks like, well, a folder.

To Delete a File

 ☛ **Exit all programs**

Double click on **My Computer**

Double click **to open the drive where the file is located** Windows Me? See page 125

Double click **to open the folder where the file is located**

Click on **the file you want to delete**

Hit **Delete key... and it's gone!**

"Access Denied???"

If the files to be deleted are in use—say you're working on the file in Word or WordPerfect—you'll probably get some cryptic message like "ACCESS DENIED," meaning you can't delete it. (At least not for the moment.) Think about it:

Trying to delete a file while it's still in use is like trying to pull the carpet out from under you while you're still standing on it. The results could be painful.

To Delete a Folder

Follow the same steps for deleting a **file**. Only this time, you don't need to open the folder. Just highlight and hit the Delete key and your **folder** is toast. (Be careful, though: You'll also be deleting all the **files** contained in that folder. So be sure you know what's inside before you dispose of them!)

"A privately owned Lucian Freud painting was accidentally destroyed by workers at London's Sotheby's. The workers apparently thought the wooden protective case in which the painting arrived was empty and put it in a crusher. The work has been valued at about $158,000."
—*Los Angeles Times*

"Oops! I Accidentally Deleted the Wrong File!"

Don't worry: Whatever you delete will be sent to your Recycle Bin and remain there until you empty it. So no matter what you delete... you can still get it back. (Usually.)

Remember: Most deleted files are stored in your computer's Recycle Bin. They're not finally deleted until you empty your Recycle Bin.

To Restore Your "Accidentally Deleted" File

Go back to **your desktop**

Double click on **Recycle Bin**

Click on **the file you want to restore** (to highlight it)

Click on **File**

Restore

Presto! Your file is safely back where it was.

You accidentally deleted an entire **folder**? Get it back the **same way** you got your file back!

"But deleting all those files takes sooo much time!"

Deleting files one by one can be tedious. (Not to mention a real drag.) So why not delete selected files or a **block** of files all at once? You'll have a feeling of control over your computer as you command whole **blocks** of files to crumble before your eyes. Here's how:

Option 1: To delete *selected files* from a particular folder:

Open **folder**

Maximize **the size of the window** (so you can see as much as possible on the screen)

Hold down **Control key and click on each file you want to delete**

Release **Control key**

Hit **Delete key** and your selected files ... will be deleted!

Option 2: To delete a *group (or list) of files* in a particular folder:

Open **folder**

Maximize **the size of the window**

Hold down **Shift key and click on the first file in the group**

Continue holding down
Shift key and click on **the last file in the group** (This will block the group of files you've selected)

Release **Shift key**

Hit **Delete key...** and your group of files will be deleted!

Empty Trash and Defrag Again!

Now that you've deleted all that clutter, to really improve
your computer's performance remember to:

Take Out the Trash (*Performance Tip #2*)

Do the Defrag (*Performance Tip #5*)

Did You Know?

Within a folder, you can delete all files older than a particular date by arranging your files by date. Just:

Open	**Folder**
Click on	**View**
	Details
	View (again)
Go to	**Arrange Icons**
Click on	**"By Date"**

Follow the "Shift-Click" method (see Option 2) to delete the entire block of files that's older than the date you've chosen.

Performance Tip #8

Archive Old Files You Don't Use (But Still Want to Keep)

Have some files you no longer use, but can't bear deleting? Consider packing them up and sending them to storage—just in case you decide to go back to that novel-in-progress one day.

You can save these files on floppy or zip disks and get them off your hard drive. You can also "zip" them—compressing them into **zip files** that will take up less space. Then it's up to you: You can leave them on your hard drive, or "archive" them on disk.

Either way, you'll be left with more free space on your hard drive, resulting in—you guessed it—better performance for your computer.

Your time at the keyboard to complete this task: 3 minutes, 27 seconds

Copy to Floppy (Or Flip to Zip)

To save on floppy or zip disk:

Insert **your floppy or zip disk in its drive**

Double click on **My Computer**

Double click on **C:** (or any other hard drive) Windows Me? See page 125

Click on **the file or folder you want to archive** (If you want to copy a group of files, hold down the Control key and click on each file to be copied)

Click on **Edit**

Cut (Don't worry, you're just getting ready to "paste" this to your disk)

Close **the C: window**

Click on **the drive letter for your floppy or zip drive**

Click on **Edit**

Paste

Now watch what happens: The light on your floppy or zip drive will turn on and you'll hear your drive spin, grind and groan. This is normal. When the light goes out, your archiving is done. (Check your oven as well. Your rib roast may also be done.)

Keep in Mind

A floppy disk can only hold so much. So if you want to copy a really BIG file, you'd do well to compress it—or "zip" it—so it'll fit on your floppy. See: the next page...

Get Hip to Zip Files

Don't confuse a **zip file** with a zip disk, zip code, Zip Lock trash bag, or a slipped disc. A zip file is simply a file that's been compressed, or "zipped." That way, it takes up less space on your hard drive. For example, if you still insist on saving that 1986 Resume file, zipping it might reduce its size by 50% or more.

"So, how do I zip a file?"

You'll need what's called an "archive utility," like PKZIP from PKWARE (www.pkware.com) or WINZIP from Win Zip Computing (www.winzip.com). These programs are readily available from the Internet, relatively inexpensive and a good addition to your software library. (Surely a better bet than "Solitaire for Two.")

And if you ever need to get back into a file that's been "zipped"... your archive utility will gladly "unzip" it!

Performance Tip #9

Give the Old "Heave Ho" to Programs You Don't Use

Ever have a computer program that was disappointing—one that just didn't work as well as you'd hoped? Or a program you used to use but no longer do? For most of us, the answer is yes.

So what do we do with these programs? We leave them on our hard drive, hogging up space and making our computer work harder to accomplish ordinary tasks.

Want a better idea? Get rid of them!

INTERMEDIATE

Your time at the keyboard to complete this task: 2 minutes, 29 seconds

"Can't I just delete the program icon from my desktop or Programs folder?"

You can, but it **won't delete** your program.

Removing a program icon is like taking the label from the back of your shirt and throwing it in the trash. You won't see the "Cool Guys" logo anymore, but that shirt of yours—the one you never wear—will continue to take up space in your closet for no reason at all.

So let's learn how to uninstall a program the right way. But first...

Don't Be Overzealous

Only consider removing programs you know you can live without.

For example, you wouldn't want to uninstall an old accounting program only to discover you've lost your Receivables file. (Ouch!) So rather than risk losing something you need, be prudent:

Only remove programs you know you can live without.

You've learned to type? Go ahead, remove "Tommy Smothers Teaches Typing." Your youngest child just turned 16? It's probably safe to remove, "Painting for Preschoolers." "DOS for Dinosaurs"? Go ahead, uninstall it.

On the other hand, older **financial** or **contact managment programs** are probably best left alone. The risk, you'll recall, is removing **valuable data** *along* with the program. So don't remove programs containing valuable data unless you know exactly what you're doing.

3 Ways to Go to Give the Old "Heave Ho"

To delete a program, first **exit** all programs. Then **restart** your computer to refresh memory lost during normal operations. Having done both those things, you may now **uninstall** your program one of three ways (depending on your program):

Method I: Use the program's own uninstall utility

Some programs build in an uninstall utility. In that case you can:

Click on **Start**
Go to **Programs**
Click on **the appropriate program** (to highlight it)
Click on **Uninstall icon** (if it has one)

With some programs, that's all you have to do to uninstall; other programs will tell you to insert the original CD. In this case, just insert the CD... and follow the prompts until you're done.

Method 2: Use Windows' Add/Remove Programs feature

If the program is listed in your Control Panel's Add/Remove Programs list, Windows can automatically remove the program:

Click on **Start**

Go to **Settings**

Click on **Control Panel**

Double click on **Add/Remove Programs**

Click on **the appropriate program** (to highlight it)

Click on **Add/Remove** (to remove the program)

With some programs, that's all you have to do to uninstall; other programs will tell you to insert the original CD and follow the prompts until you're done.

Method 3: Use a third party uninstall program

For programs that are so stubborn they won't allow you to uninstall them using the first two methods, you can purchase utility programs—like Norton CleanSweep (Symantec) and Uninstaller (McAfee)—that will properly uninstall Windows programs. Just tell 'em Elliott sent you.

Empty Trash and Defrag Again!
Now that you've ditched those old programs, remember to:
1. Take Out the Trash (*Performance Tip #2*)
2. Do the Defrag (*Performance Tip #5*)

Performance Tip #10

Reduce Unnecessary Startup Routines

When you start your computer, certain programs start automatically. Their engines are on and they're ready to go. But what if you rarely or never use these programs? You may even be starting programs you're not aware you have. (I met with one home user who had a popular audio program, Real Player, as one of his automatic startup routines—and his computer didn't even have speakers!) Yet there they are, automatic startups that "automatically" clutter up your system and soak up memory.

In fact, you can eliminate, or **lose**, many of these automatic startups without missing a thing. (The programs will still exist on your computer and—if their icons were on your desktop—they'll still be there.) What your machine will **gain** however, is some valuable memory that was otherwise engaged. Better yet, you'll enjoy a **more stable, less crash-prone** computer.

Your time at the keyboard to complete this task: 5 minutes, 42 seconds

Step 1: Identify the programs in your automatic StartUp folder

Click on **Start**

Go to **Programs**

StartUp

Write down the names of all your programs in the StartUp folder. These are some of the programs that start automatically—every time you turn on your computer. Seriously...

Do You Really Need to Start "Solitaire for Two" *Every Time* You Turn On Your Computer?

This is like having fresh-brewed coffee 24 hours a day. Nice idea if you're a diner. But otherwise, a waste of valuable resources. So let's get rid of these needless short cuts.

Remember

It's only those automatic startup routines you'll be getting rid of—*not the programs*. Later, if you decide you'd still like some of those programs to start automatically, you can re-install them with just a few clicks. Meanwhile...
Do not proceed to Step 2 until you exit by clicking on your desktop.

Step 2: Create a new folder for automatic startup routines you can probably live without

Exit all programs

Right click on **Start**

Left click on **Explore**

Maximize **the window** (if it's not already the size of your screen)

Find **the Programs subfolder** (by looking under the Windows folder, then the Start Menu subfolder)

Click on **Programs** (to highlight it)

Click on **File**

Go to **New**

Click on **Folder**

Name your new folder **Old StartUps** (by typing Old StartUps in the New Folder box)

Step 3: Remove programs from the StartUp folder

While still in Explorer:

Click on **the + sign next to Programs** (on the left side of your screen)

A list of the contents of the Programs folder will appear.

Click on **StartUp** (under Programs on the left side of your screen)

The contents of your StartUp folder will appear on the right side of the screen .

Click, hold and drag **program icons** (from right side of screen) **to Old Start Ups folder**
(on the left side of the screen)

Release **the mouse while icon is on top of Old Startups...** and your move is complete!

Continue this process for all programs you don't think you need at startup.

"But how do I know what I don't need at startup?"

Use common sense and these handy pointers:

1. If you have schedulers or programs that remind you to pay bills or send birthday cards in your startup routines—but you never use them—you don't need them in your StartUp folder.

2. Any program you regularly access by clicking on a desktop icon or going to Start/Programs does not belong in your StartUp folder.

3. Programs you no longer use, belong—big surprise!—in your **Old StartUps** folder.

4. Be prudent: If you don't know what it is... **do not move it** out of your StartUp folder.

5. Whatever you do, **do not move your antivirus auto protection** from your StartUp folder! (If it's there, keep it there. If it's somewhere else, don't worry about it.)

Time to Check Our Progress Again!

Step 1: Write your performance level from page 10 here:

Original _____ % free

Step 2: Restart your computer

Step 3: Check your performance level again and write it down here:

Current _____ % free

Better, isn't it? That's because you **identified and removed unnecessary startup routines**, eliminating distractions to your computer and regaining valuable memory.

And Now... As Promised to You!

If you still feel you want certain programs to start automatically, just repeat Step 3. Only this time, click, hold and drag program icons from the **Old StartUps** folder back to the **StartUp** folder.

Finally

If you find that you don't need these programs at all, you may wish to uninstall them. To uninstall them in the **proper manner**, see *Performance Tip #9*.

For Extra Credit

Down in the lower right corner of your screen you'll find icons for things like the volume control, fax programs, and scheduling and calendar programs, all of which—necessary or not—are starting automatically. These are TSRs and a bit advanced for the scope of this book. However... if you have more than **six icons** in this portion of your screen you may be suffering from **startupitis**. Not as bad as a skin rash, but it can cause a variety of **startup hazards**. To learn more, roll up your sleeves and visit www.pcmaestro.com.

Now How Well is Your Computer Running?

Earlier, you checked your available hard disk space. Now let's measure your improvement.

Step 1: Check your current available hard disk space and note it below
(see page 11 for instructions)

Current free space (Drive C:) _____ bytes

If you have other **hard drives**, continue with:

Current free space (Drive D:) _____ bytes

Current free space (Drive E:) _____ bytes

Step 2: Compare these numbers to your *original* available hard disk space
(the numbers you wrote on page 11)

Congratulations! If you followed just some of the tips in this section, your available hard disk space will have increased significantly—and your computer will be working faster and more efficiently!

Your time at the keyboard to complete this task: 0 minutes, 51 seconds

Keep in Mind

It's a good idea to regularly check the overall space on your hard drives—to see how much space is **used** and how much is **available**. That way, you'll know if your clean up routines need to be more aggressive or if you can wait another day.

Windows performance can be improved or degraded depending on remaining space available on your hard drives. If your computer seems sluggish or is not performing like it used to, you may be running out of room. Check available space on your hard drives to see if you are running low on space.

Unfortunately, there are no specific rules or guidelines to identify how much free space should be on any one machine. However, if you have less then 25% available space, you could soon be running into trouble.

To free up additional space, review *Performance Tip #s 2 through 9*.

Part II
Preventive Maintenance Tips
Keeping Your Computer Running Right

Preventive Maintenance Tip #1

Save, Save, Save

You just spent all morning finishing up a key report. Then your computer went dead. Or your brain went dead when your computer asked: "Save Changes?" and you hit "No."

Now all that work may be gone forever—unless you obeyed the most important commandment in your computing life:

Save

Your time at the keyboard to complete this task: 0 minutes, .5 seconds

Never Work Longer Than Five Minutes Without Stopping to Save

Don't take that phone call without hitting Save.

Don't go to that staff meeting without hitting Save.

And don't go to lunch without hitting Save. Even better, exit all programs and give your computer a nap. (See page 15)

Remember:

Save, Save, Save
Can save you lots of grief!

Preventive Maintenance Tip #2

Get Saved (Automatically!)

You're in the middle of working on a document when your computer locks up and all you can do is shut it down. Or the power goes off—and your heart's in your stomach. If you've been smart—saving your work every five minutes—all you're at risk of losing is your last few minutes of work. (Not so bad.)

But if you haven't saved your work for the past three hours or so, you're at risk of losing a lot. (Not so good.)

However

Microsoft Word and Corel WordPerfect both offer "auto save" features—built-in protection against this kind of accidental loss. Designed to automatically save your work on a regular basis, these "auto save" features give you a good chance of recovering your work— even if you forgot to save for the past three hours.

So let's make sure you have them turned on. Better "auto save" than sorry.

Your time at the keyboard to complete this task: 1 minute, 17 seconds

BEGINNER INTERMEDIATE

Step 1: Make sure "auto save" is activated on your system

For Microsoft Word:

Click on **Tools**

 Options

 Save tab

Check the box **next to "Save AutoRecover info every: ___ minutes"**
(if it's not already checked)

Click on **OK** and you're set to save automatically

For Corel WordPerfect:

Click on **Edit**

 Preferences

Double click on **Files**

Check the box **next to "Timed document backup every ___ minutes"**
(if it's not already checked)

Click on **Apply,** then **OK** and you're set to save automatically

Step 2: **To save more frequently, put a lower number in the minutes box**

The more frequently you automatically back up, the less work you risk losing.

Caveat Savior (Let the Saver Beware)

These "auto save" features are for emergency use only. In the event of a crash or power failure, they may not recover your documents 100% of the time. So don't rely on them as a substitute for manually saving your documents. (Besides, how much work is it to click Save now and then?)

"Help! My computer just crashed and I didn't save!"

No problem. To recover with "auto save", just reboot your computer and open Word or WordPerfect. You'll often find your document right there **on the screen**—with all your changes as of the last auto save. If not...

For Word:

Click on **Tools**

Options

File Locations tab

Your document can now be found in the folder listed under "Location" for AutoRecover files!

For WordPerfect:

Click on **Edit**

Preferences

Double Click on **Files**

Your document can now be found in the folder identified next to "Backup Folder."

Once you recover your document **SAVE IT** or it **will be deleted** when you exit the program.

Preventive Maintenance Tip #3

Back Up, Baby, Back Up

One day your computer gets seriously damaged—by a virus, a faulty hard drive or a curious two year old. Suddenly—unless you back up regularly—you're at risk of losing your files, programs, financial records, business contacts, personal settings and more. Get the picture?

To prepare yourself for this doomsday scenario—which could happen to you!—you'll want to create an **up-to-date backup copy** of your **entire system**. That way, you'll have the key to getting up and running again 100%. As football legend Vince Lombardi put it:

"It's not whether you get knocked down. It's whether you get up again."

To ensure you can get up again, a two-tier system will do the trick: **Tier 1**, backing up your **data** (to protect key files) and **Tier 2**, backing up your **system** (to protect your programs and personal preference settings).

Tier I: Back up key *files and data* every time you change or update them

Many software programs—like Quicken, Quickbooks, Microsoft Money, ACT and others—have built-in backup routines that automatically prompt you to back up on a **floppy** or **zip disk**. They're easy to follow and could wind up saving you big. While they **usually prompt you** to back up, they **may not prompt you** every time you add new information. So...

What happens when you enter 20 new names in your address book and you don't get prompted to back up? Your data will get saved on your hard drive, but it won't get backed up. That means you run the risk of **losing your data**. So...

When you store large chunks of new data **and you don't get prompted**, back up on your own. Just click on File and you'll usually find Backup listed. If you don't find Backup listed, go to Help ... and that should help.

"What about programs that don't have built-in backup routines?"

For programs **without** built-in backup routines, you can back up your files manually on a floppy disk, zip disk or CD ROM. (If you need them, your files will be easier to access than they would be on tape.) To back up to CD ROM, you'll need a rewritable or recordable CD ROM drive—which is fast becoming a standard feature on new computers. But if you're still computing back in the 20th century, you may not have one yet. So...

To Copy to Floppy (Or Flip to Zip)

Insert **your floppy or zip disk in its drive**

Double click on **My Computer**

Double click on **C:** (or any other hard drive) Windows *Me*? See page 125

Click on **the file or folder you want to copy to highlight it**

(If you want to copy more than one file, hold down the Control key and click on each file to be copied)

Click on **Edit**

Copy

Close **the C:** (or other hard drive) **window**

Click on **the drive letter for your floppy or zip drive**

Click on **Edit**

Paste

Now that you've backed up, remove your disk, label it with the contents and date, and put it someplace safe. That little disk—containing your files and data—is a valuable asset.

Your time at the keyboard to complete this task: 3 minutes, 27 seconds

"Help, it says my floppy doesn't have enough room!"

The copy to floppy method just described—while quick and easy—has a limit of one floppy disk. If your file requires more than one disk, you'll need to use a **backup utility**.

To back up on multiple disks (using Windows' built-in backup utility):

Click on **Start**

Go to **Programs**

Accessories

System Tools

Click on **Backup**

Follow the step-by-step instructions and—with patience—you'll make it through. Meanwhile, if you run into language like "Backup has created a full backup file set for you" just click OK and keep moving on!

If Backup isn't listed under System Tools, you may need to install it. Instructions are on www.pcmaestro.com. Also, you may not be able to use this utility if you have a tape backup system. (But don't let this stop you from getting one.) If you really want to back up lengthy files onto disks—and that's a good idea—there are other backup utilities you can install that will work with a tape backup system. For more information, check a computer store or ask your techie cousin.

Tier 2: Back up your *system* at least once a week

To protect your programs and personal preference settings, use a **tape backup system**. Floppy disks, zip disks—even CD-ROMS—have a limited capacity and just won't do the trick. If your system is totaled, you'll need a method that can restore **all of your information**—not just part of it.

A tape backup system gives you *crash insurance for your entire system*—allowing you to copy everything—*all your programs, files and data*—with one or two clicks of your mouse.

While the exact steps to run a backup vary from manufacturer to manufacturer, take the following steps before you back up:

Step 1: Shut down all programs and restart your computer

Step 2: Shut down any automatic startup routines, including your anti-virus program

You'll find icons in the lower right hand corner of your screen. These icons represent programs that are still running. So if you don't shut them down now they won't get backed up. Generally, you can right click on the icon, then click on either: Disable, Shut Down, Close, Remove or Get Rid of the Darned Thing! If you can't find those commands—or something similar—go to Help... and that should help.

Step 3: Disable your screen saver

See *Performance Tip #5*, page 32.

Your time at the keyboard to complete this task: Less than a minute, and it's worth it!

Rotate and Verify

It's not enough to back up routinely. You also need to have multiple backup tapes and rotate them by using a different tape each week. That way, if one tape is defective, your next backup will be on another tape. (And hopefully, a good one.)

Also, verify your backup each time you run it. Most backup programs offer confirmation that the backup really worked—or that it didn't. Look for status reports or error logs. Worn out tapes, defective tape drives or program problems can cause incomplete backups. (If you see a list of files that weren't backed up, it may indicate that a program or utility was not fully closed before you started.)

You can diligently back up every week for years. But if you don't rotate and verify, Murphy's Law says your tape will go bad the week before your system crashes. And you won't know if you didn't verify. And you won't have another backup tape because you didn't rotate. The result? Disaster. Despite all that diligence, your precious information will be gone forever! (So do sweat the details.)

To Schedule or Not to Schedule?

Most backup programs include a backup scheduler, allowing your computer to automatically back up at pre-set times. These schedulers work fine and usually do their job. But they also take up a small amount of memory that could otherwise be available to your system. More importantly, when you automatically back up, you tend to forget—you guessed it!—to rotate and verify. And that could spell... complete disaster.

What's the Value of Backing Up?

Depending on how you use your computer, the information contained in those backups—all the programs, files and data you've compiled—could be incredibly valuable. Not to mention irreplaceable.

Take It Outside

Whatever backup method you choose—floppy and tapes, CD-ROM and tapes, or even a second hard drive—keep backing up! And keep your copies in a safe location. To protect yourself in case of fire or damage, store your files and backups outside your home or office. To really "take it outside" you can store your data **on the Internet**. Usually, there's a small monthly fee. Options include: Connect.com (www.sgii.com) and Xdrive (www.Xenterprise.com).

Eight Years Work Go Up in Smoke

When a wildfire swept through New Mexico, it burned more than 400 homes and closed the Los Alamos National Laboratory. It also destroyed valuable data: A scientist at the lab lost his computer hard drive and **all his backup data disks—eight years of work**—when his office was destroyed. He backed up, alright. He just forgot to keep his backups somewhere else.

Remember:

To go forward, you must back up.

When the "ILOVEYOU" virus struck the Norwegian photo agency, ScanPix, the agency had, according to a CNN report, "between 700,000 and 800,000 photos in their archives, **but good backup routines saved most of the photos.**"

Preventive Maintenance Tip #4

Keep Your Anti-Virus Software Current

Anti-virus programs are flu shots for your computer. But just because you have Norton or McAfee (both leading programs) don't assume you're protected: This is like getting the flu vaccine one year and figuring you're set for life. **No, you're set for TODAY**. An anti-virus program only inoculates your system from viruses known at the time the program was created.

Hackers and virus writers work day and night—mostly night—to hatch "new and improved" viral strains. Just one year after the Melissa virus (1999), for example, came the faster spreading and more insidious Love Bug (2000), wiping out attachments, documents and files on e-mail. What's coming next? More mischief and mayhem. Meanwhile...

Take a pro-active approach to virus protection:
Update. Update. Update like mad!

Your time at the keyboard to complete this task: 3 minutes, 16 seconds

BEGINNER

INTERMEDIATE

What Can Happen When You Don't Update Like Mad

A chemical engineer subscribed to various e-mail lists to keep current on research in his field. His virus definitions were current through January '99. In early **February** '99, he downloaded an e-mail attachment that infected both his home and office computers with the HAPPY 99 virus. He was **one week late** in updating virus definitions. One week. Seven lousy days. Yet it knocked him off the Internet for a week and cost him nearly a thousand dollars to repair.

In May 2000, a virus disguised as a love note—the "ILoveYou" virus—hit millions of users worldwide, including NASA, the CIA, the Pentagon and Britain's House of Commons. Why should your house or office be considered any safer?

"Okay, I'm Ready to Update!"

Method I: Automatic updating

You can download virus definition updates from the Internet using your virus program's automatic update feature. This downloads and runs virus updates with a few clicks of the mouse. Updates are available weekly—and more often when a particularly insidious virus appears. These updates are either free or reasonably priced. And they're *very simple* to use.

To Use Automatic Updating:

Step I: Close all programs and restart your computer

> **BE SMART: Do not skip this step!**
> Restarting your computer will maximize memory—increasing your chances for a non-interrupted Automatic Update.
> **After** you've restarted—and only then…

Step 2: Find your anti-virus program

Click on Start, go to Programs and look for Norton, McAfee or whatever anti-virus program you have.

Step 3: Update

For Norton AntiVirus

Click on **Live Update-Norton AntiVirus**

Follow **on-screen instructions**

For McAfee VirusScan

Connect to **the Internet** (but do not start your browser)

Click on **McAfee VirusScan Central**
UPDATE button

Follow **on-screen instructions**

Method II: *Super* Automatic Updating

Since virus writers are getting so ingenious these days, anti-virus companies are following suit. There are new anti-virus methods springing up all the time. (Like having your system scanned and updated every time you surf the Net.) So stay abreast of the latest technology. Both Norton AntiVirus (www.sarc.com) and McAfee VirusScan (www.nai.com) have extensive websites featuring the "latest and greatest" in virus protection. Add these sites to your Favorite Places or Bookmarks and visit them frequently. You'll be super hip about super automatic updates and have lots to talk about with people you want to impress.

Method III: Manual Updating

While automatic updating features are quick and easy, they can be interrupted—like when your Internet connection goes down in the middle of a download. If this happens, your download won't complete and you may have to start over. There's also some risk that automatic updating will **appear** to be complete when it's **really not**. And you may not know about it until sometime later— when your system gets corrupted by a virus that **could have been** prevented.

So while dowloading your updates manually takes a **bit more time**... it also offers a **bit more protection**. For the super diligent, go to www.pcmaestro.com for complete details.

"Can't I just get my computer to schedule updates?"

Most anti-virus programs allow you to schedule your updates—so your "automatic" updates happen automatically. But like any other task scheduling, this can lead to a false sense of security. Be smart: Don't take even the slightest chance with something as important as virus protection!

Preventive Maintenance Tip #5

Run Your Virus Scan Regularly

Keeping your anti-virus software current protects you against known viruses that could infect your system in the future. What you're not protected against is a virus that may be **lying dormant** on your system.

So keep your computer as healthy as possible by scanning your entire system once a week.

Don't worry, it's easy.

Your time at the keyboard to complete this task: 1 minute, 16 seconds

To Virus Scan Your System:

Step 1: Go to your anti-virus program

Click on **Start**

Go to **Programs** and look for Norton, McAfee or whatever anti-virus program you have

Step 2: Scan

For Norton AntiVirus

Once you arrive at Norton AntiVirus in the program list, a pop up list will appear.

Click on **Norton AntiVirus** in the pop up list and wait for the program to open

Scan for Viruses or Scan Now

For McAfee VirusScan

Click on **McAfee VirusScan Central**

Scan or Scan Now

All Fixed Drives (If you have the option.) Otherwise, scan each drive (C:, D:, E:, etc.) individually.

Step 3: Pat Yourself on the Back...Told you it was easy!

From Safe to *Super Safe*

Most anti-virus programs give you the option of scanning Program Files or All Files. Checking **Program Files** will scan for most types of files, including Word documents. And that's pretty good. To be safer, however, do a monthly scan of **All Files**. (To be really, **really** safe, do a weekly scan.)

Step 1: Go to your anti-virus program

Step 2: Set your program to scan all files

For Norton AntiVirus

Click on **Options**
Scanner tab

Check **All Files** (not Program Files)

Make sure there's a check in the box next to "Within compressed files."

For McAfee VirusScan

Click on **Scan**

Settings

Check **All Files** (not Program Files)

Make sure there's a check in the box next to "Compressed files"

Step 3: Scan your system

Need instructions? See page 100.

Preventive Maintenance Tip #6
Practice Safe Computing

As children, most of us learned not to take candy from strangers. Yet as adults, many of us are all too ready to take an e-mail called "VERY FUNNY" and open its attachment with abandon. But instead of some "brain candy"—like the joke of the day—what you can wind up with is a nasty virus. (The joke, you'll discover, will be on you.)

Loading programs from the Web, or borrowing a disk or homemade CD, can be equally problematic—even if you know and trust the source.

So be smart. Be sensible. And practice safe computing at home, in the office and in cyberspace. (Besides, does anyone really need *one more joke* from the Web?)

Your time at the keyboard to practice safe computing?
A whole lot less than if you don't.

"All of the features that make the Internet exciting, fast, dynamic and open go against security."

Bruce Schneier, chief technical officer, Counterpane Internet Security

"The problem's only going to get more acute, and the solution will not be solely technological. You have to educate your users better about good hygiene in cyberspace."

Richard Power, editorial director, Computer Security Institute

Okay, let's get educated!

In most cases, e-mail viruses won't work their damage unless you open an attachment. So be careful out there in cyberspace: **Never open an attached file without first scanning it**. That way, you'll know if it harbors a virus or not.

Take similar caution when downloading from the Web and never open a **download** without first scanning it. Meanwhile, if a download seems at all questionable, ask yourself: "Is getting this download worth the risk?"

Also take caution when using disks or CDs—even if you **know and trust the source**. A floppy disk— even from a fellow worker who means no harm—could be loaded with a nasty virus. So if someone gives you a disk containing documents, programs or any other type of file ... **scan it before you use it!**

"Won't my anti-virus program scan automatically?"

Unfortunately, not all anti-virus programs automatically scan e-mail attachments and Internet downloads. For the best protection, scan each downloaded file **manually** right after you save it. That way, you'll definitely know that your anti-virus program has done its work.

WARNING: Do not open until you've scanned. Otherwise, you could risk infection.

To Manually Scan New E-mails, Downloads, Disks and CDs

Step 1: Locate the file

If you don't know where the file is:

Click on **Start**

Go to **Find or Search**

Click on **Files or Folders**

Type **the name of your file in the Named: box**

Select **My Computer for the Look-in: box**

Check **Include subfolders** (under Advanced Options in Windows *Me*)

Click on **Find Now or Search Now**

Step 2: Scan the file

For Norton AntiVirus

Right click on **the name of the file**

Left click on **Scan with Norton AntiVirus**

After a few seconds—or minutes or weeks, depending on your computer—Norton should respond that no viruses were detected. If it tells you you're infected… follow on-screen instructions and wash hands thoroughly.

For McAfee VirusScan

Since your McAfee may not scan individual files, go ahead and scan the entire **folder**. (This will scan the file you're interested in as well as the rest of the files it contains.) So after you find the file, look under **In Folder** and write down the name of the folder. (You'll need a pen or pencil to do this. Not state-of-the-art, but sometimes useful.) Then…

Open **McAfee**

Click on **Scan**

Browse

Double click on **My Computer**

Find **the folder or subfolder and CLICK on it**

Check **All Files**

Click **Scan Now…** and let your machine do the rest

After a few seconds—or as much as a few years, depending on your computer—McAfee should respond that no viruses were detected. If it tells you you're infected, follow on-screen instructions and wash hands thoroughly. To be extra safe, burn or bury your clothes. (But first, be sure to remove them.)

Keep in Mind

Your best insurance against a virus is having an **up-to-date backup** of your entire system. It won't **protect** you from getting a virus... but it will get you up and running again. (See *Preventive Maintenance Tip #3*, page 79.)

Preventive Maintenance Tip #7

Be a ScanDisk Fan

Your computer's hard drive, you'll recall, is like a big jigsaw puzzle. That's why you need to "do the defrag"—to organize those pieces and put them closer together. (If this doesn't sound familiar, either you skipped a tip or you just plain forgot.) Over time, however, not only will those pieces become disorganized, they can also become **damaged**. That's where Windows' ScanDisk utility comes in—searching for **errors** and making **repairs**. So those puzzle pieces can fit together again.

Your time at the keyboard to complete this task: 0 minutes, 38 seconds

To Run ScanDisk

☞ **Exit all programs**

Disable **all screen savers** (See *Performance Tip #5*, page 32)

Click on **Start**

Go to **Programs**

Accessories

System Tools

Click on **ScanDisk** Make sure the box marked Automatically Fix Errors is checked

Click on **Start**

Once a week, run a **Standard** ScanDisk. Once a month, run a **Thorough** ScanDisk. If you have more than one hard drive, make sure you run ScanDisk on *each* hard drive and your Zip disks. Don't bother running ScanDisk on your CD-ROM. It won't do a thing.

"Doesn't ScanDisk run automatically? Like when my computer freezes and I have to shut down by hitting the Off switch?"

This kind of shutdown is like tossing millions of puzzle pieces up in the air. Once you restart your computer, ScanDisk will activate automatically—Windows' way of assessing the damage by sending out "all the King's horses and all the King's men."

Better to avoid the non-normal shutdown. Otherwise that hard drive of yours—just like Humpty Dumpty—may never get back together again.

Preventive Maintenance Tip #8

Be Prepared: Make an Emergency Boot Disk

You turn on your computer one day and get a cryptic message like: **Non System Disk** or **Invalid System Disk** or some gobbledygook like **Insert Bootable media into drive**.

What does all that mean?

It means your computer is unable to "boot up," or get itself going. Either your hard drive has become damaged due to normal wear and tear, a virus has done its dirty work or an electrical surge has fried a thingamajig.

If you're prepared with an **emergency boot disk**—and you're an average, or even an above average computer user—you probably won't be able to use it anyway. Then why bother to create an emergency boot disk? So Tech Support—or your techie cousin—can use the disk to diagnose the problem and, quite possibly, get you running again.

Be a good citizen: Be prepared with a boot disk—or be prepared to have a lot more problems. Because someday, someone may need to use that disk.

INTERMEDIATE

Your time at the keyboard to complete this task: 0 minutes, 53 seconds

To Create An Emergency Boot Disk

☞ **Exit all programs**

Click on **Start**

Go to **Settings**

Click on **Control Panel**

Double click on **Add/Remove Programs**

Click on **the tab for Startup Disk**

Insert **your floppy disk** (blank, but formatted)

Click on **Create Disk**

You may be asked to insert the original Windows CD (or a few diskettes) so the necessary startup files can be copied to your floppy disk. After they're copied, remove the disk and label it **Windows Emergency Boot Disk**. You may even want to create a pair of these and keep them in different places. So if you can't remember where you put one, you may remember where you put the other. (It's a neat little trick, but it won't work with shoes.)

Remember

Be sure to close, or lock, the "write protect" tab on the back of your disk to protect it from virus infection. If your computer went down because of a virus, rebooting it with your emergency disk—unless that tab has been locked—could result in spreading that virus directly to your disk. So use "write protect." Otherwise, if you or your techie cousin use that disk again, you stand an excellent chance of infecting your computer. And that's a bit of mischief you want to avoid.

Preventive Maintenance Tip #9

Be Further Prepared: Make an Anti-Virus Rescue (or Emergency) Disk Set

What happens when your computer catches a virus? Normally, your anti-virus program can serve as the cure. But sometimes, even your anti-virus program needs help. That's when you'll need a set of anti-virus rescue disks—to help you boot up again and clean your computer from the offending virus.

Don't worry, it's easy.

Your time at the keyboard to complete this task: Up to 19 minutes, 54 seconds
But well worth your time!

To Create an Anti-Virus Rescue (or Emergency) Disk Set

For Norton AntiVirus

First, have five blank, formatted disks. Then:

Click on **Start**
Go to **Programs**
Norton AntiVirus
Click on **Rescue Disk**

Follow on-screen instructions.

For McAfee VirusScan

First, have one blank, formatted disk. Then:

Click on **Start**
Go to **Programs**
McAfee VirusScan
Click on **VirusScan Control**
Tools
Emergency Disk

Follow on-screen instructions.

Preventive Maintenance Tip #10

Don't Let Crashing Get the Better of You!

You're working away when you get an Error Message on your screen telling you your program has performed "an illegal operation." While not as serious an accusation as, say, treason, the downside to "an illegal operation" is instant punishment: Your computer freezes or forces you to close down the program.

Sometimes—in spite of your best efforts to use your system properly—Windows has a panic attack and crashes or becomes unresponsive. Suddenly, as they say, your computer is down. But you don't have to be.

For example...

Your time at the keyboard to fix this mess?
That depends on how much time you spend screaming at your computer.

ADVANCED

If You Get an Error Message...

Try clicking on **Ignore** or **Close**. Sometimes it's as simple as that.

If Your Computer Freezes...

Hit the **Ctrl-Alt-Delete** keys and hold them down at the same time. You'll see a **Close Program** window listing all programs that are actively running. Highlight the program you were in when you froze and click on **End Task**. If you get the message "Program not responding," try clicking End Task again. This usually solves the problem by closing the program. If this doesn't work, try the same for other programs that are running.

If you do force a program to close with **Ctrl-Alt-Delete**—or switch your computer Off—you will lose **unsaved work**. If you followed *Preventive Maintenance Tips #s 1* and 2, however, you won't be losing much, if any, work at all.

If You *Can* Close an Error Message or Unfreeze a Freeze...

Your problem was probably isolated and not a sign to worry. To be extra cautious, though, you should:

Save **all your work**

Exit **all programs**

Disconnect **from the Internet**

Restart **your computer**

Next, try starting the program that caused the problem and see if the same thing happens. Chances are, it'll run just fine.

If You *Can't* Close an Error Message or Unfreeze a Freeze...

Keep hitting **Ctrl-Alt-Delete** until your computer shuts down. As a last resort—and keep trying everything else before you go there—you may need to manually shut down your computer by switching it Off.

Next, restart your computer and try recreating the error by running the offending program with **no other programs running**. You'll see if the program is generally problematic or whether the instability was a one time thing. Or maybe you were just running too many programs at the same time.

Also, try to remember: **What was going on just before you crashed?** That way, you'll be prepared when Tech Support (or your techie cousin) asks: *What programs were running? Were you in the process of saving, spell checking, printing or exiting the program? Were you on the Internet? Were you saving a file to a floppy or zip disk? Were you playing jump rope with the electrical cord?*

Finally, if your computer *keeps* crashing, it's time to ask: "Am I hexed? Is my future doomed? Or should I be more careful about following the **Tune Up Calendar** on the following pages?"

Conclusion

If you've followed the advice in this book—or even some of it—your computer is running better than ever.

But to *keep* it that way will require a bit more effort. So to help guide the way, you'll find a **Tune Up Calendar** on pages 126-127. Follow it well and you'll continue to be rewarded with smoother, faster, more reliable performance. You may even find yourself shouting out loud...

"Yes, this little book really works!"

Windows Me?

If you've just started using Windows Millenium (Windows Me) you may need to make a few adjustments —especially if you're used to Windows 95 or Windows 98.

1. To find "System" in the Control Panel:

After you click on Control Panel, click on "View all Control Panel options." Various options, including "System," will then appear.

2. To view the folders and files in your C: drive (or any other drive):

After you open the drive, click on "View the entire contents of this drive" and you'll... view the entire contents of this drive! (Who knew computing could be so easy?)

Tune Up Calendar

Whenever You're Working

Give your computer a nap (every 4 - 6 hours)	*Performance Tip #1 (page 13)*
Save your work (every 5 minutes)	*Preventive Maintenance Tip #1 (page 73)*
Back up key files and data (every time you update them)	*Preventive Maintenance Tip #3 (page 79)*
Virus scan disks and CDs	*Preventive Maintenance Tip #6 (page 103)*
Virus scan your e-mail attachments and internet downloads	*Preventive Maintenance Tip #6 (page 103)*

After Every Internet Session

Clean out your e-mail boxes	*Performance Tip #3 (page 21)*
Clear your temporary internet files (or disk cache)	*Performance Tip #4 (page 25)*

Daily

Empty your recycle bin	*Performance Tip #2 (page 17)*

Weekly

Do the defrag	*Performance Tip #5 (page 31)*
Clear your Windows temporary files	*Performance Tip #6 (page 37)*
Back up your entire system	*Preventive Maintenance Tip #3 (page 79)*
Update your virus definitions	*Preventive Maintenance Tip #4 (page 91)*
Give your system a standard virus scan	*Preventive Maintenance Tip #5 (page 99)*
Run a standard ScanDisk	*Preventive Maintenance Tip #7 (page 109)*

Monthly

Delete files and folders you don't need	*Performance Tip #7 (page 43)*
Archive files and folders you don't use	*Performance Tip #8 (page 51)*
Uninstall programs you don't use	*Performance Tip #9 (page 55)*
Clean out your StartUp folder	*Performance Tip #10 (page 61)*
Give your system a complete virus scan	*Preventive Maintenance Tip #5 (page 99)*
Run a thorough ScanDisk	*Preventive Maintenance Tip #7 (page 109)*
Make an emergency boot disk	*Preventive Maintenance Tip #8 (page 113)*
Make an anti-virus rescue disk set	*Preventive Maintenance Tip #9 (page 117)*